BALLROOM HARRY

Photos and text by Harry Goaz

Edited by Jason Reimer with assistance from Kristen Butler
Afterword by Bettina Gilois and Jason Reimer

DEEP VELLUM PUBLISHING
DALLAS, TEXAS

Deep Vellum Publishing
3000 Commerce St., Dallas, Texas 75226
deepvellum.org · @deepvellum

Deep Vellum is a 501c3 nonprofit literary arts organization
founded in 2013 with the mission to bring
the world into conversation through literature.

All rights reserved.

Copyright © 2020 by Harry Goaz

Support for this publication has been provided in part by grants from the National Endowment for the Arts, the Texas Commission on the Arts, the City of Dallas Office of Arts and Culture's ArtsActivate program, and the Moody Fund for the Arts:

ISBN: 978-1-64605-004-8 (hardcover) | 978-1-64605-005-5 (ebook)

Library of Congress Control Number: 2020931108

BALLROOM HARRY : VOLUME II IS A TALENTED FRIENDS PRODUCTION OFFERED BY DEEP VELLUM
BOOKS ©2020
TALENTEDFRIENDS.COM

ANGELLAIRRANCH.COM

THE COVER PHOTOGRAPH WAS TAKEN BY STEPHANIE WATEL
ADDITONAL PHOTOS WERE PROVIDED BY PETER SALISBURY AND BETTINA GILOIS

CREDITS#####

VOLUME II

Jimmy Adams
Desi Brite
Claire Dishman
Kristin Ohmstede

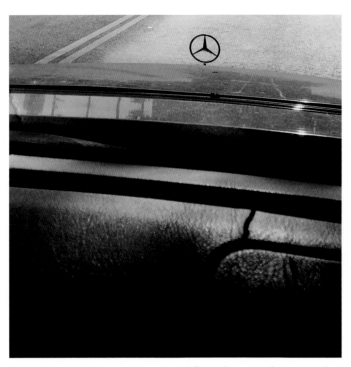

He used to practice running scared from the woods. Every day.

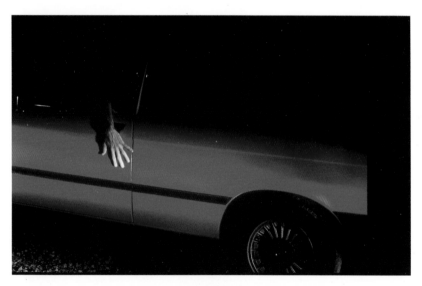

Dishman Dam

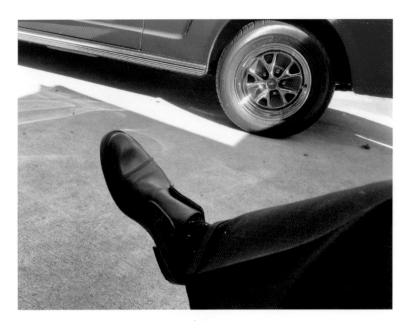

Bark Stone

There was a tiny sparkling tear running down her face right over the emu oil.

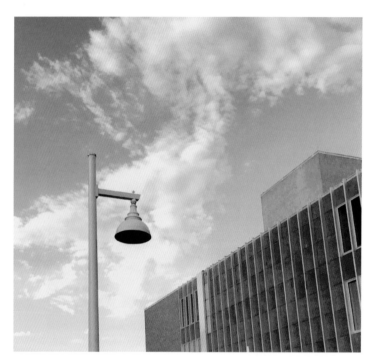

Note to self: cheat on test.

I'm so lucky that I never know where I am.

2.

666

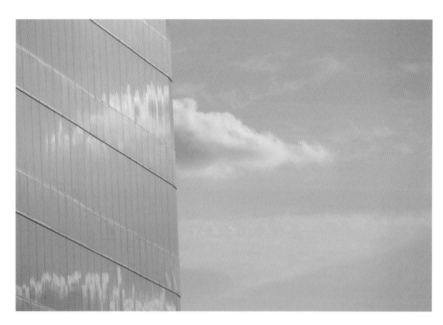

Out of jail and still a scumbag.

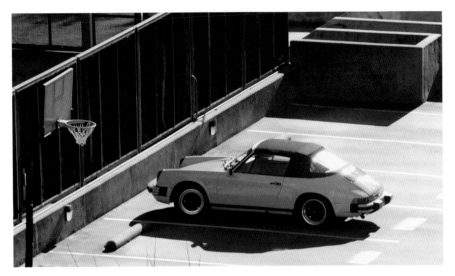

I would like to be you for just over five years.

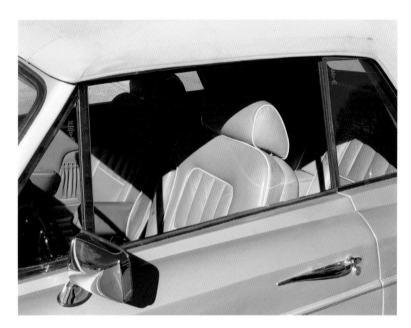

Lights, camera, Ambien . . .

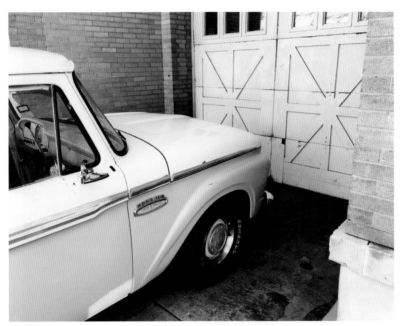

Real charity begins backstage.

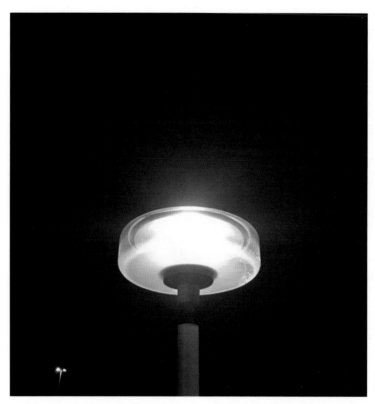

By nature I am not a gregarious person, but my stalkers make up for it.

It's like the time I saw Tippy's ghost on the side of Bel Air Road.

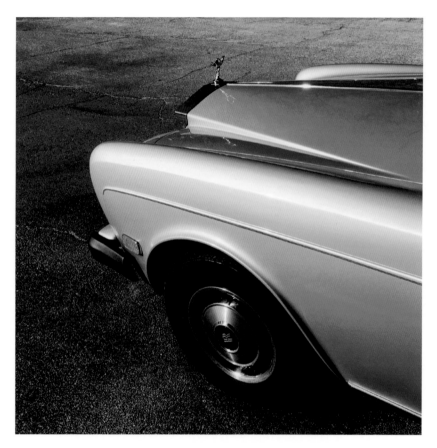

Our love is paler than a Durer etching.

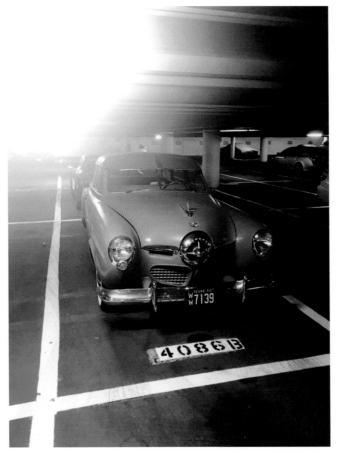

More stories about the dankest day on the face of the Earth.

May the bridges that I burn light the way.

If you won't be my rock n roll circus I will die.

Your love is exponentially larger than anything I
was counting on.

LA City, I love you.

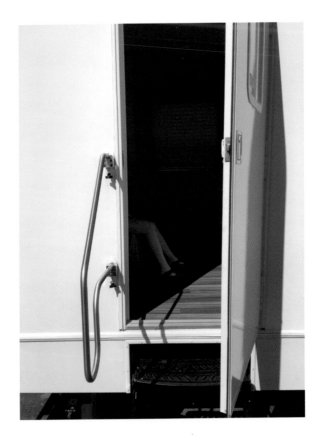

Kimmy running lines.

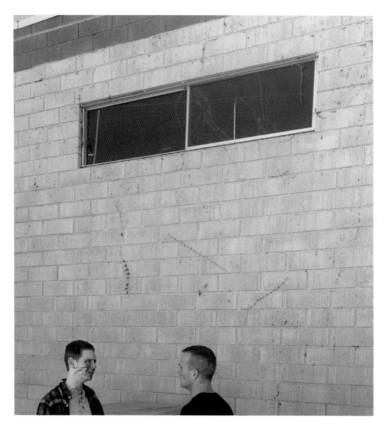

Actors

Sometimes the only thing left in life is a brilliant marriage.

?

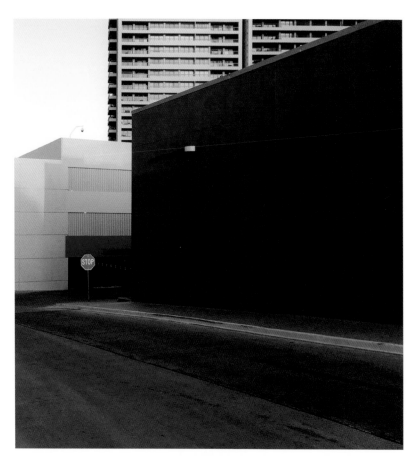

Is there anything more exciting than coming home and finding out that someone has cleaned your gun? And you live alone. In the middle of nowhere . . .

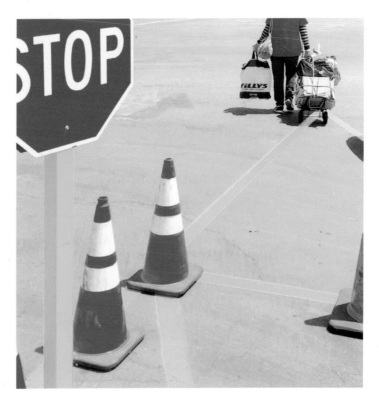

Usurpers

W Hotel Hollywood

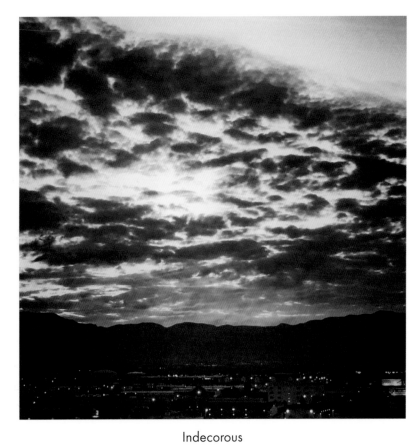

Indecorous

It was like the time I let the devil stare deeply into my eyes and I stared back.
For a long time.

Your restraining order against me is about to expire.

Memphis, Tennessee

I have a story to tell and it's not going to happen.

Wild at heart and weird on top.

As a young boy he worked earnestly to become a slave to his own desires.

I want to learn how to chop down a big tree.

We danced like Yoko was on drums. All weekend long.

It's going to happen today despite my ragged breathing.

Door A

Door A and Door B in same frame

It's like the time I found you in the formal dining room of the fancy hotel drinking a malted.

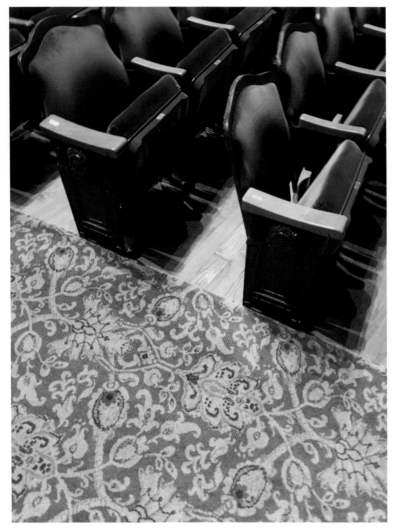

One night I wasn't listening to Doris Troy on the stereophonic record player and went here instead.

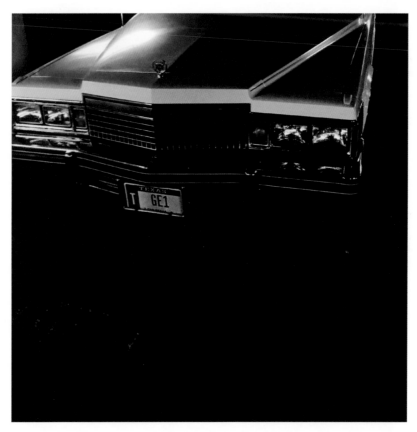

Raina said this. Raina said that. She can parallel park on two tries.

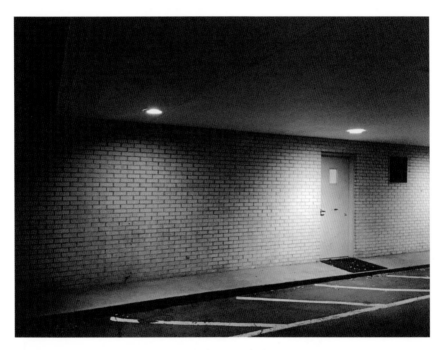

There is no such thing as light carpentry.

It was the very week I was in Albuquerque, but thought I was in Phoenix.

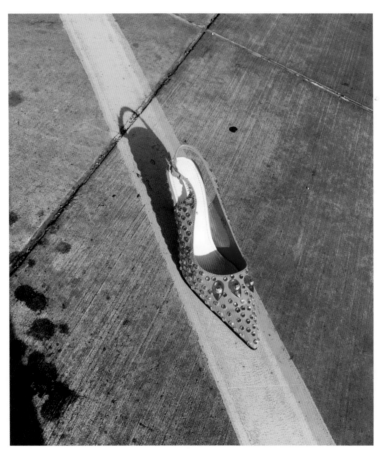

Gore, Oklahoma

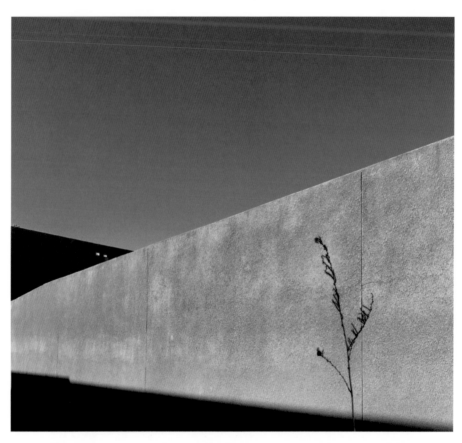

What witnesses were these and why weren't we made aware of them
in discovery?

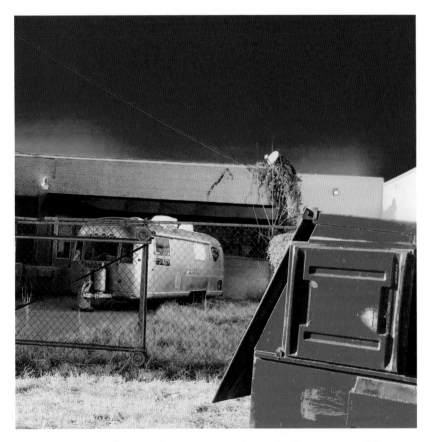

Leon had big plans and dreaming made up the largest part of them.

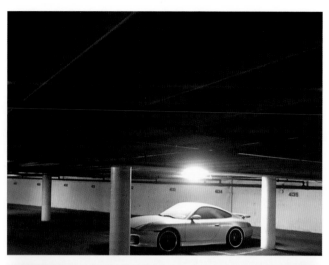

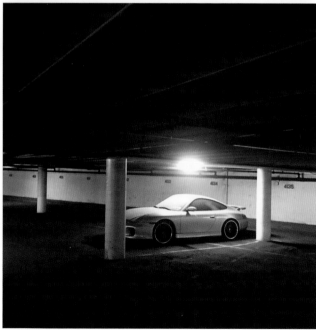

Turtle Creek Boulevard
Dallas, Texas
2012

Trucker
Muskogee, Oklahoma
2016

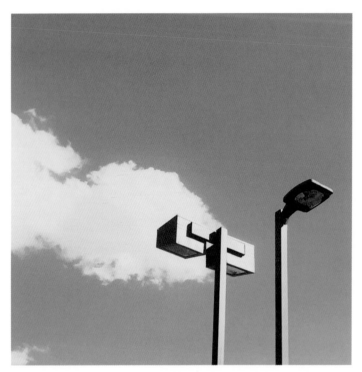

Sky
plate 2
aqua

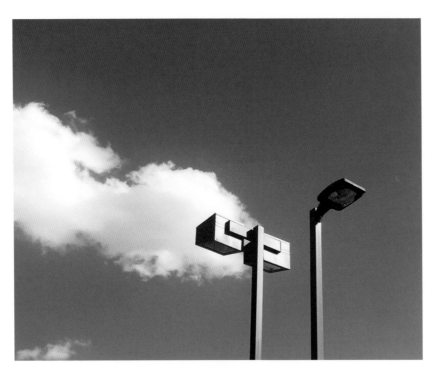

Sky
plate 2
blue

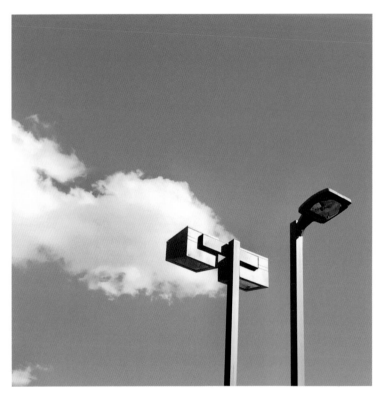

Sky
plate 2
black/white

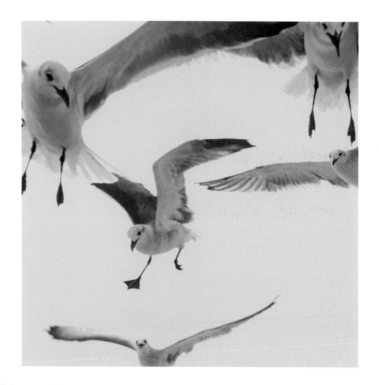

One of the most luxurious aspects of being a fraud is the ability to change the rules at leisure and without much thought.

Tyler in Cabin

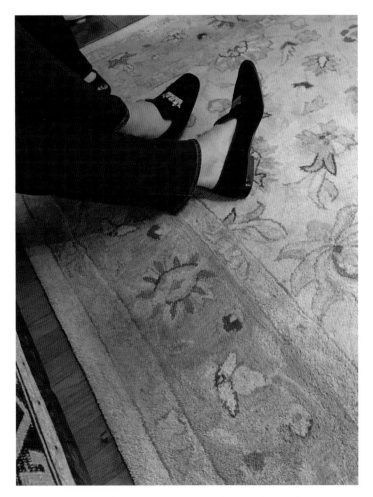

Bigger than a movie star on Bettina's couch.

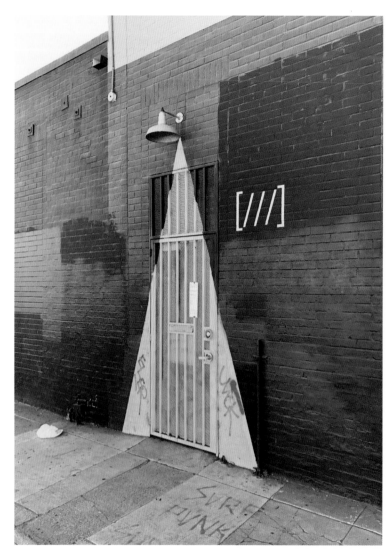

When one door opens, another door opens.

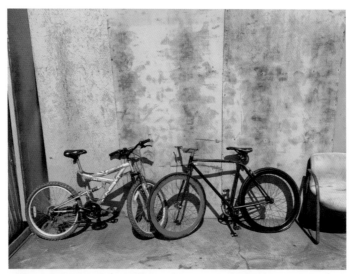

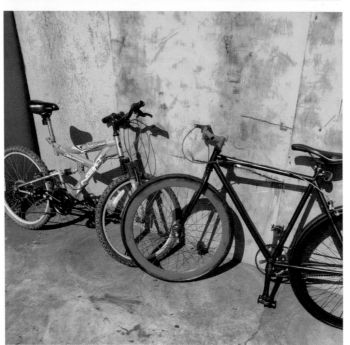

Melrose Avenue
Hollywood, California
2015

I could participate in mayhem on principle alone.

I want a car the color of rust.

It's like the time my girlfriend dressed me up as a rich lesbian for an entire year.

As a young boy Wade loved pulling nails out of wood.
That is all he loved. Ever.

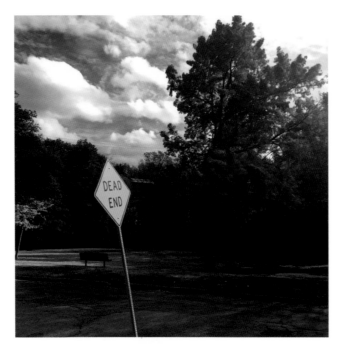

Dead. End.

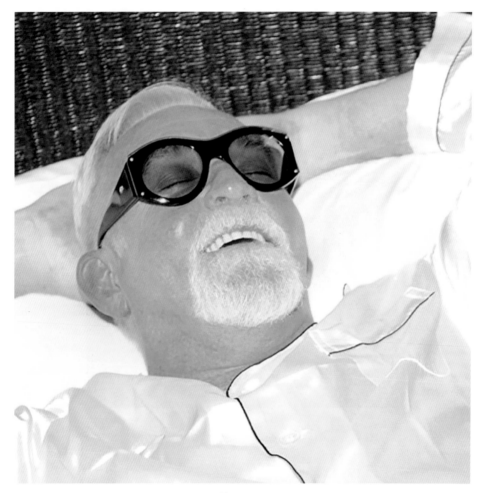

Tycoon

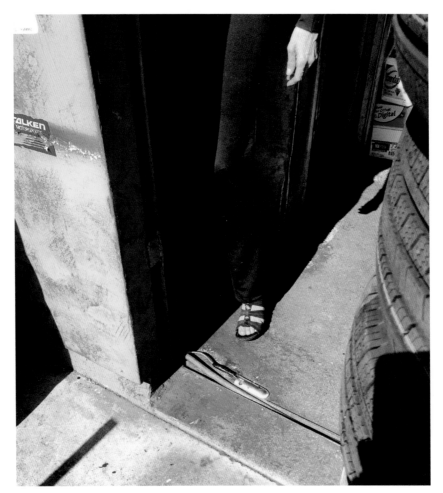

It was like Sherman's march to the sea.

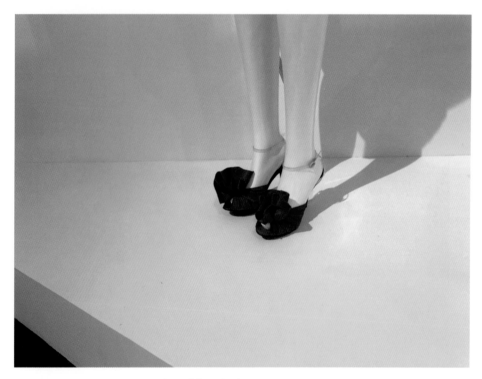

Capable. Ambitous. Hungry.

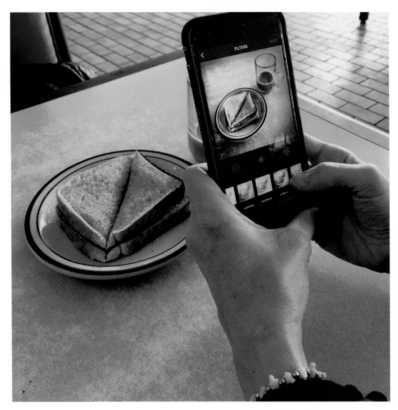

Toast and Hottest Chick in the World
Albuquerque, New Mexico
2014

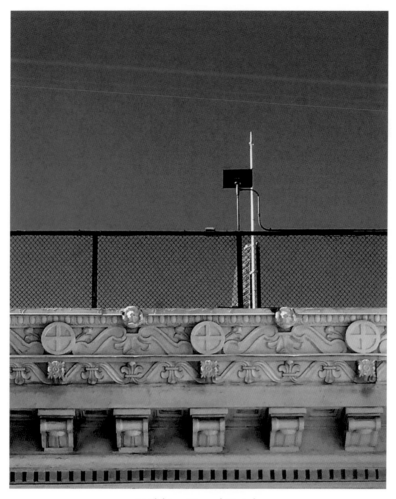

Wilshire Grand Hotel
black/white
2016
Nikon D5

More urban myths about zesty background vocals.

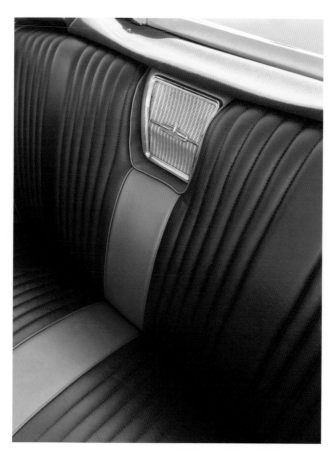

I've spent a lifetime going to where I didn't belong.

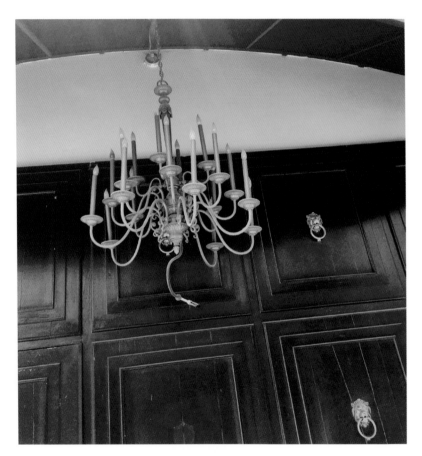

Light Fixture
Hollywood, California
2016

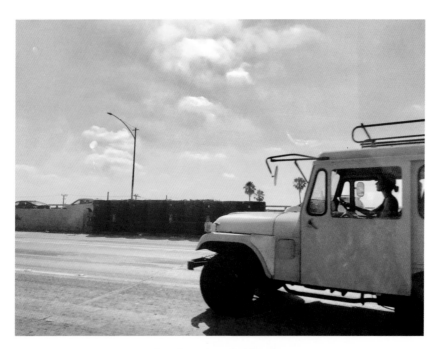

Los Angeles, California

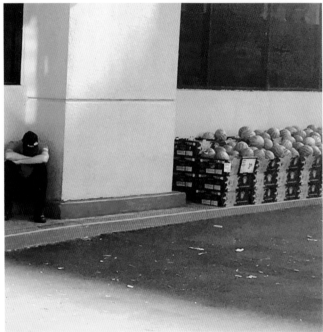

Melons
Hollywood, California
2011

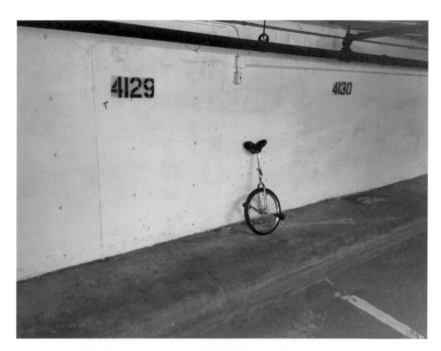

Garage
plate 1

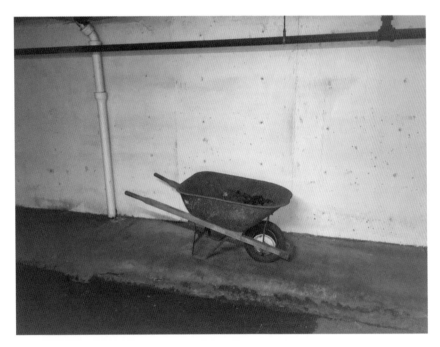

Garage
plate 2

I waver when the punch line is told.

More stories about Portuguese knife fights and how cleaning your
oven can be toxic to your health.

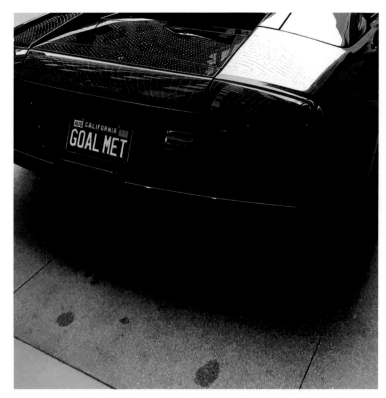

One night while sitting very still, Jesus told me that my larger dreams
would be every other person's hate bait.

In the studio with Xxxx X and Bettina.

I told the world how much I loved you in your ransom note.

Kimmy and Sabrina
Los Angeles, California
2017

Los Angeles Athletic Club
Los Angeles, California
2016

Tears flow as the queen dons her crown.

I want my neighbors to listen to some great music whether they like it or not.

The twelfth of never can't get here soon enough.

The city is the real protagonist here.

Woman finds teeth in disco.

My life with the Medellín Cartel and how I suffered migraines every other day.

Man in robe robbed McDonald's with brush.

Sweet, sweet, delicous bipolar sunrise.

Remember when I was your favorite person in a coma?

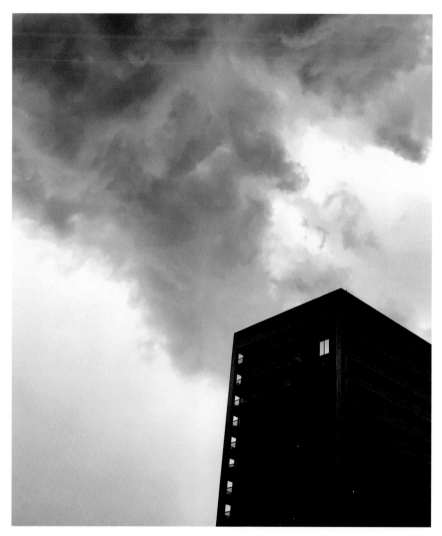

Remember when you were young enough to spot trouble a mile away?

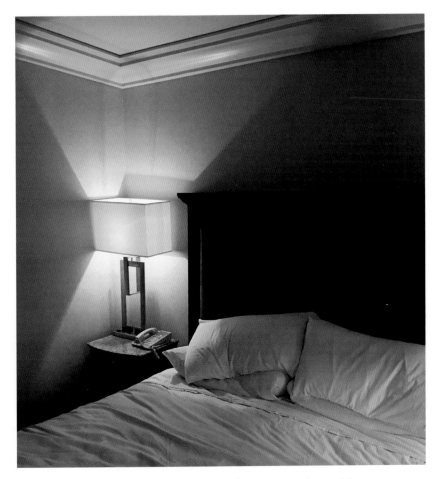

Tell girls all of your secrets if you want a better life.

If you ain't rotating your crops you are messing with your future.

Your love is like the dimmest light at the carnival.

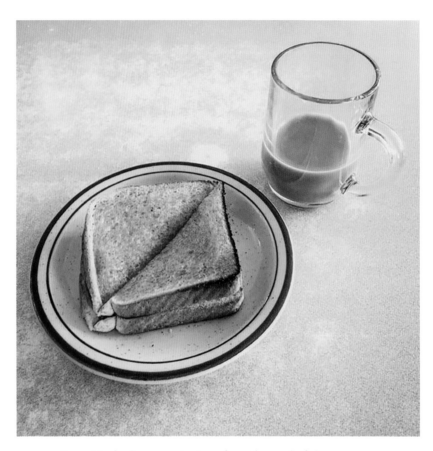

Dear God, please protect me from the end of democracy.

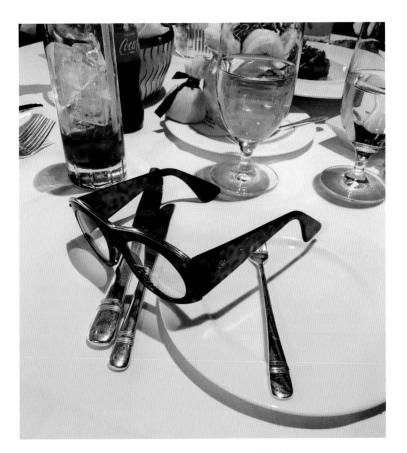

I am your river. I am your flood.

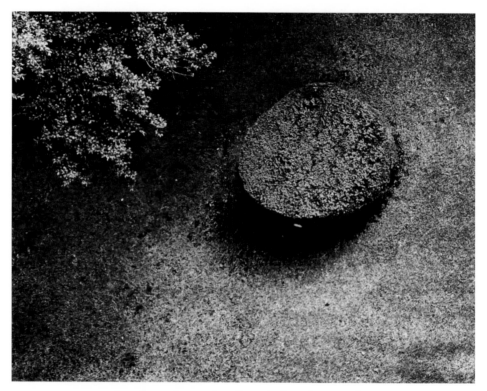

Lonely on the inside. Crowded on the outside.

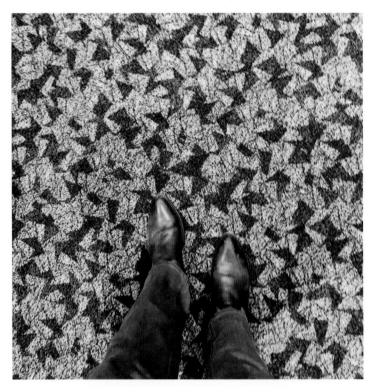

From the fog of abuse steps a warrior.

If I worked at the Daily Beast I wouldn't even take a coffee break.

I'm the one who loved you when you started choking at the salad bar.

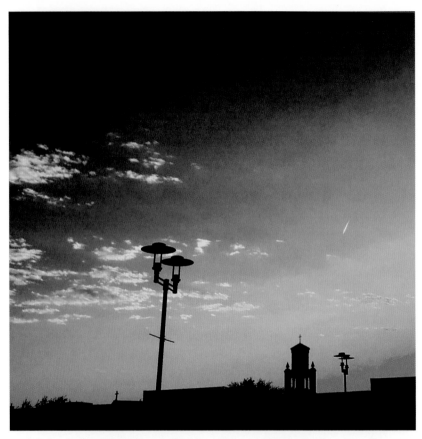

While hate showered the earth, there was a serious wreck out on the 105.

We all know the truth about really nice people.

My inner beauty is exhausting the shit out of me.

I want to chew your heart like a stick of gum.

My people-surviving skills are at an all-time high.

Perversion is its own indicator of genius.

Life is more than blunts and 8 balls.

I want to be the answer to a really important question.

Margaret's predilection for chicken carbonara led to her downfall. Then she won the lottery.

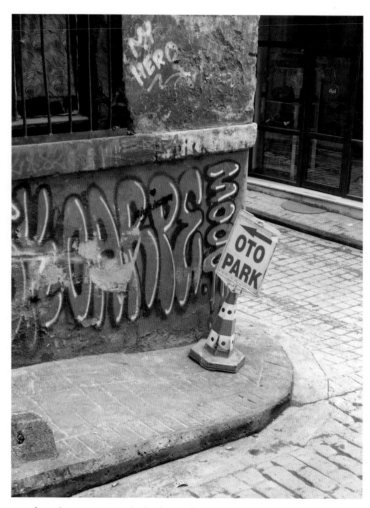

Some of us die every single fucking day because we can't make magic.

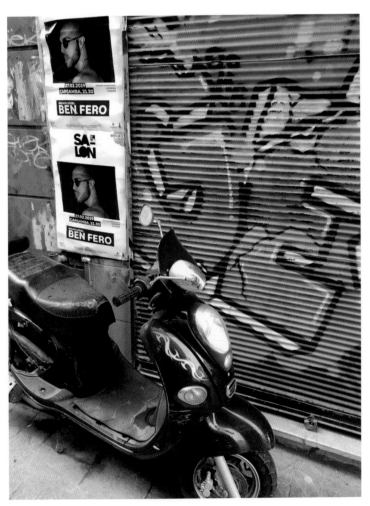

I love you more than the time you demanded a lie detector test in Fresno.

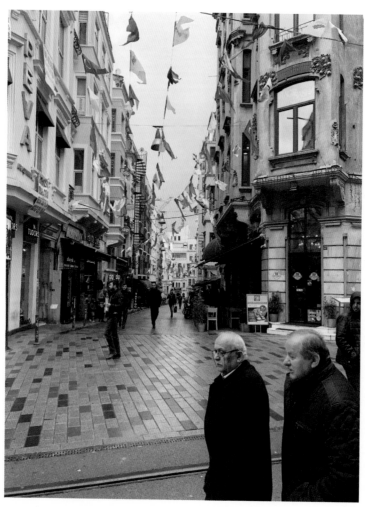

She invited me everywhere I wanted to go, but she was always distracted.

Fifteen miles outside of Lubbock she spotted a steak house from the plane.

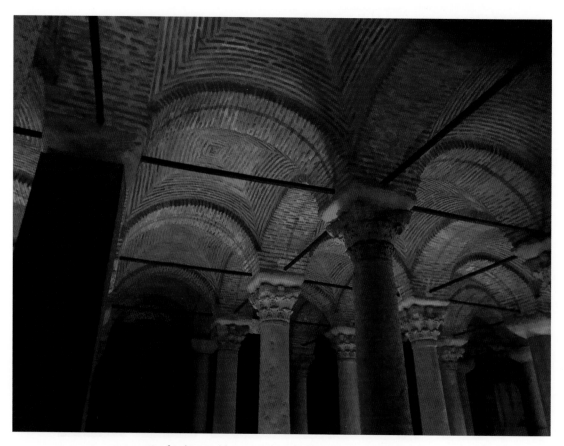

I'm frightened by people who live in the daylight.

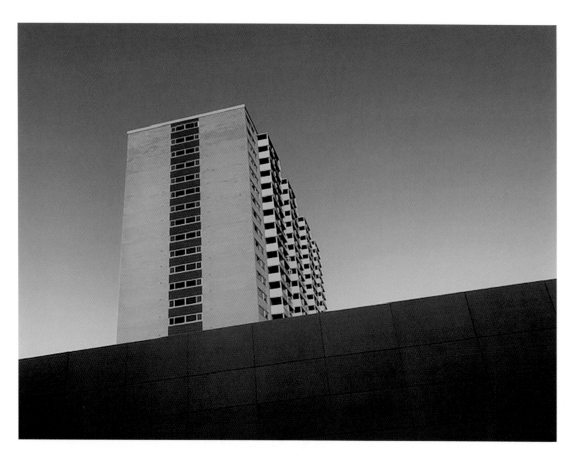

The universe just gave me an upgrade.

Gwen
Dallas, Texas
1977

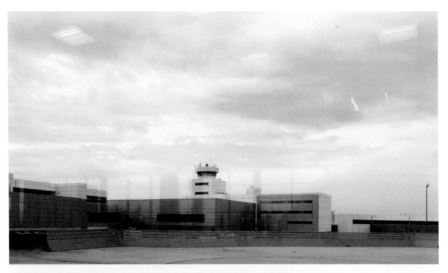

Live in two cool places, but not at the same time.

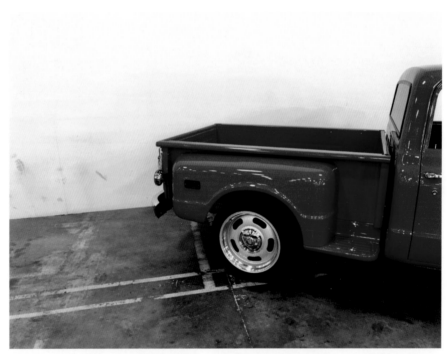

Seventeen years ago he was conceived on the bench press at the gym on San Vicente.

If you're reading this it means that I'm already onstage.

Here I stand absent of thunder and purpose.

wellbutrin XL 300mg qAM
wellbutrin XL 150mg qAM
Zoloft 50mg qAM

Another pagan with a busy sword.

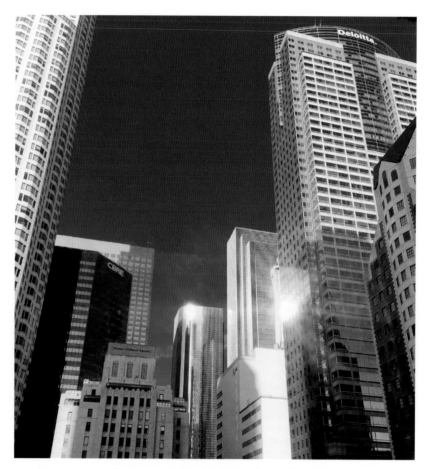

More stories about crazy time lords and how cleaning your oven
can be toxic to your health.

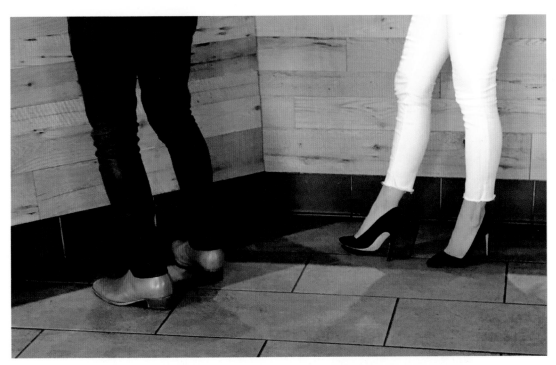

LA, you are my most beloved friend.

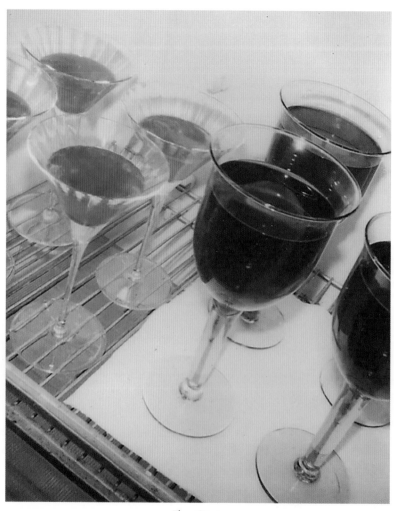

The Ojai
Hollywood, California
1985
Polaroid

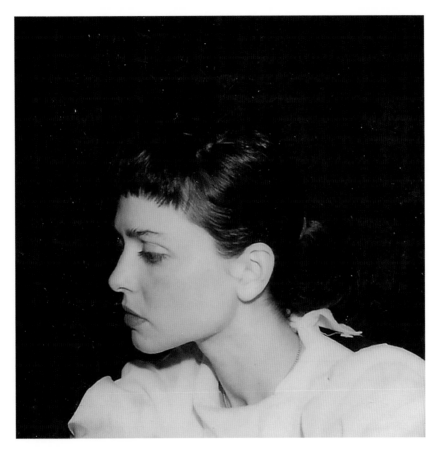

Kristin
Evangeline Drive
1979

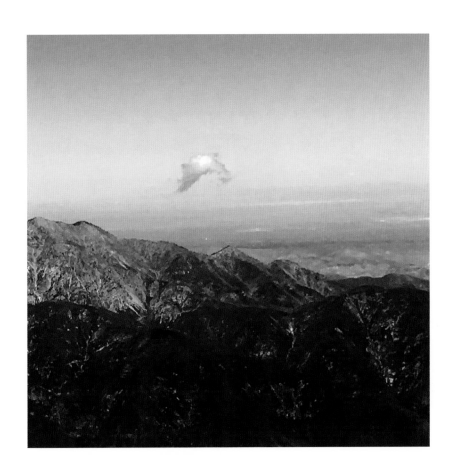

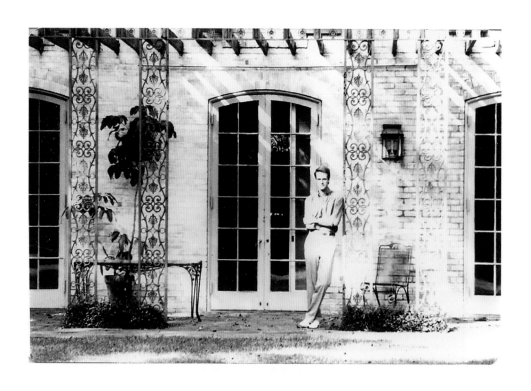

BIO

Harry Goaz began his artistic career as a casual observer growing up in Texas. His quiet nature allowed him access to some of the most exclusive enclaves of society, both real and imagined. This skillset served him well when he picked up a camera and began photographing the world around him. He traveled extensively and often found himself in the right place at the right time. Ultimately unsatisfied with the local offerings, he found his way to Los Angeles and eventually landed the role he's so well known for on the television series *Twin Peaks*. This successful role was followed by another on *Eerie Indiana* before Goaz stepped back into the obscurity where he feels most at home. In a time when the pursuit of fame is ubiquitous with every level of society, anyone taking notoriety and hedging at exploiting it is downright revolutionary. So in 2015 when word came that he would reprise his role for David Lynch, the series title "The Return" carried multiple meanings for Goaz. Prior to this, Goaz hadn't been seen or interviewed for years. It was at this juncture that he connected with Director Jason Reimer, who was originally asked to "make something" with Goaz in conjunction with an article about his life between TV stints. The result was the short film *Figurehead*, which depicts Goaz as a frustrated artist waiting in a broken-down home for a phone call that will change his fate. The film has since been added to *Twin Peaks* lore as many don't know how accurate the portrayal might be. After this collaboration, Reimer and Goaz began meeting about further collaborations; the first result is this collection of photographs.

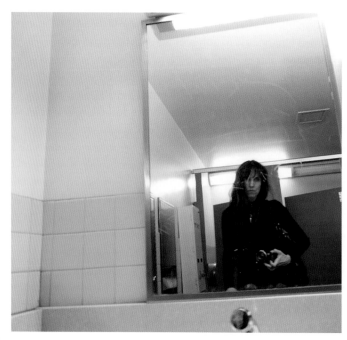

BETTINA GILOIS

Cars Are Important

We were throwers of parties. In ballrooms and guesthouses ghosted by Maurice Chevalier and Barbara Stanwyck. We were ambitious neurotics. We wore leather pants. But didn't think we deserved them. Our martinis were doubles and dry at Musso and Frank's. We wore wigs in daylight and still, to our surprise, we were recognized. Someone always had handcuffs. We extolled the virtues of *caprese* and brown chicken from Chinatown. We were throwers of the *I Ching*. We were friends of David Byrne, Don Henley, Timothy Leary. Our birthday cakes were phallic. One night, Barbara Leary went down on the cake. It was the grandest of times in 1992.

At the top of Whitley Heights, high in the Hollywood Hills, we lived on one street and knew our neighbors. Our houses were on stilts, staked into mudslide slopes. We were naïve not to recognize how we lived on the precipice of our fates.

At night, the lighted cross on Highland Avenue floated in the coyote brush. On Hollywood Boulevard Frederick's of Hollywood was open all night. We went to Jumbo's Clown room and Club Fuck! and had drive-ons at the studios. We made New York look like Calcutta.

And then the world blew up. A black man was brutally beaten. Four white men walked. And LA exploded with a flame throwing righteous rage.

We stood at the top of Whitley Terrace, with that view of the LA basin. The kids on the hill. Staring down as the city burned from left to right. One of us had a movie deal. Another knew Bertolucci. Another one had an antique rifle. It didn't work but it seemed relevant. On good days you could see the ocean. On this day black smoke and curling fire devoured the basin grids like a wave. There was a curfew on. Police swarmed the streets. National Guard was on the way. US Army. Marine Corps. The news told us all to stay home. Do not go to burning South LA.

Naturally we went.

Day two of the riots, Harry and I climbed into his pristine white Chevrolet Silverado pickup truck.

The tires gleamed with Armor All. The interior was blue. Richard Prince had once called it "pretty." He didn't mean it nicely. But we liked the tinted windows and the high chassis. And we drove down Crenshaw south of the 10 to see what was happening to LA.

It was a bright and sunny day. Storefronts were burning. Station wagons rumbled with couches, mattresses, dinette sets strapped to the roofs. Like everyone was moving out. People ran through the streets with VCRs, televisions, radios, boom boxes, loaves of bread and shoes, so many shoes. There was shouting, whistling, sirens, honking, gun shots. It was bigger than any party we had ever thrown. We knew this was a true story that wasn't ours to crash.

We turned the Silverado home.

But we had witnessed. We had seen. And that was what mattered.

Harry and I liked the same things. Bingo in the Inland Empire. Champagne at Spago's. Truck stop coffee. Alaia at Regen Gallery. Flapjacks at Angel Diner. And cars.

Riding in the truck, you had a big screen on the world. And we wanted to see it all. We drove through the barrens of Johnson Valley on the Pearblossom Highway when the roadside Last Supper still stood. We drove through New Mexico ghost towns in the Gila Mountains where Johnny the Fireman saw lights in the sky. We climbed the Sierra arroyos to the Ortega Ranch and Harry held the calves on branding day.

In desert wastelands, in mountain outposts, in urban ruins, in Hollywood ballrooms, people dream and desire.

We wanted to witness. We wanted to experience. We wanted to speak about what we saw.

In the many decades I have known Harry, I have always wanted to follow him around with a notepad to write down the ruptures of brilliance that burst from his mind. But then I don't because they are his brilliance, and rather than capture, I let him release those reckless poetics into air like captured butterflies. Because they deserve to be free. Because no one sees the world like Harry Goaz.

Luckily his brilliance is captured here in this book.

Important things hide between unimportant things. A hand on a red car is all you need to know about Dishman Dam. You know it was humid. You know it was late. The kids were young and beautiful and tawny tan. They were looking for meaning in the rice fields of Texas.

Harry's photography captures these fractal moments, fragments of stories, shards of life, with sharp observation of flashes of human yearning, wishing, believing, with hints of there always being more to the story.

His observational ironies lie between the revealing and the withholding. Between those gaps there is mystery and yearning and pathos and redemption.

A cloud reflected in a skyscraper. "Out of jail and still a scumbag."

Rotted cardboard with shriveled tomatoes on pavement. "Your restraining order is about to expire."

A vintage car with pristine brown leather interior. "Lights, Camera, Ambien . . ."

Kimmy Robertson's stockinged legs captured in the shadows of a production trailer, austere like a Hopper painting.

Images like a held breath. His photographs are evocative, suggestive, and lonely. Because we always yearn for more.

And cars are important.

In the Whitley Heights summer of '92, I lived in the ballroom and Harry in the chauffeur's quarters. It was one of those days we needed to get out of town.

Harry and I drove the Silverado down the coastal route to North County California, with its fish taco stands and surfboard waxers. I had a deadline. He had Paul Bowles to read. We stayed in the Del Mar

hills with a view of the ocean. But our fates were calling us back to LA. We tried to remain for a few more days, but we had listened to too much Merle Haggard on the cassette player all the way down, and even the sunshine was bumming us out.

We rode back up the coast in silence. Until we looked at each other. Merle sang "Are the Good Times Really Over (I Wish a Buck Was Still Silver)." We knew for us both, there was love, life, and loss to come. And we knew together we would survive them.

Harry ejected the tape and threw Merle Haggard out the window.

Bettina Gilois
Los Angeles, California
2020

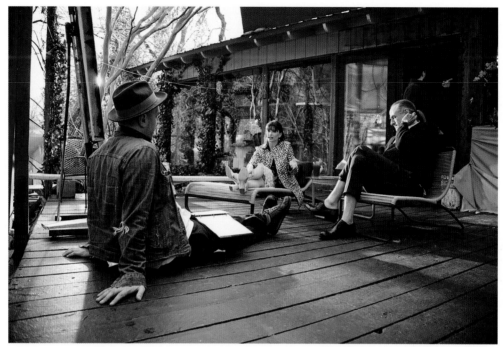

(L-R) Reimer, Brandy Burre and Goaz on the set of *"Figurehead"* photo: Peter Salisbury

My collaboration with Harry Goaz seemed to have begun even before I met him. The familiarity I felt when we met in the lobby of his building to discuss working together made me grin as my deja vu finally caught up to reality.

We'd been nudged together to "make something" by a newspaper in anticipation of his return to TV and both of us were keen on warping whatever expectations had formed in the minds of our matchmaker.

The first handful of times we met we talked about lots of things that had nothing to do with making anything at all. Time travel was a topic. Harry is an infamous recluse so there's a fair amount of playful fencing when you meet him. He's warm and funny, but often seems to be hiding something in his pocket while he wonders if he should show you or not.

There were many magical moments throughout making the FIGUREHEAD film, and Harry seemed right at home. The surrealist blur of his waking life bled into the semi-ficticious account of where he'd been for the last 20 years and further distorted the truth, which was exactly what we wanted.

One day he casually mentioned that he had boxes of photographs sitting upstairs in his apartment and the idea for this book began to take shape. It didn't surprise me to find out he had a love affair with photography. He's quiet and unassuming, which gives him the ability to soak into a room and become a neutral observer. This attention to the moment is his greatest asset as a creator but you'd be hard pressed to guess correctly what he's thinking. And the suprise is always worth your patience.

He has the best memory of anyone I've ever met and oozes a southern charm that's addictive. It takes awhile before you start to see the precocious rascal he also inhabits. He doesn't have to do much to exude a lot. When you hear stories about his friends and their relationships, you realize how rarified these moments are and it changes you. Everything he tells you feels like a secret, like you're walking into a private club you've been dying to get in.

The effortless notation of the moments he captures don't have the trappings of someone vying desperately for accolades, but a more enticing elusive style of someone you can't quite pin down. Harry doesn't use social media, he already was what it proposes to be; a small glimpse behind the curtain of a fascinating person I feel lucky to know and honored to collaborate with.

Harry being Harry, he trusted that his photos could be edited and his "subtitles", as I call them, would be paired in a way that felt natural. There were no rules given. He insisted on collaboration. Kristen Butler helped edit through a considerable amount of photos and I paired these with a list of his phrases and arranged the book in what felt to me like a song. Harry gave us license to make those edits and suggested that a cosmic pairing should be the guide. There was some talk about whether the need to put subtitles underneath certain photos was apparent, and I'll only answer this, that it just seemed correct. There's no need to try and decipher what additional meaning they might add, although you might find as I did, they often do. Just as it is to know Harry himself, when you look again, you'll probably see something you didn't notice before that will make you laugh as deja vu catches up to reality.

Jason Reimer
Feb 10 2020